Post your finished work and join the comm

#FAITHINCOLOR

Be Still, My Soul

90-DAY BIBLE STUDY COLORING JOURNAL

PASSIO

I never saw a useful Christian who was not a student of the Bible. If a man neglects his Bible, he may pray and ask God to use him in His work, but God cannot make much use of him, for there is not much for the Holy Spirit to work upon. We must have the Word itself, which is sharper than any two-edged sword.

—D. L. MOODY

How to Study Your Bible

Study to show yourself approved by God, a workman who need
not be ashamed, rightly dividing the word of truth.
—2 TIMOTHY 2:15, MEV

Most Christians recognize the importance of studying their Bibles. Doing so is the only way we can come to know God as He is, grasp how much He loves us, learn what He expects of us, and discover the purposes for which He created us. As we spend time in His Word, reading and reflecting on it, we are sometimes convicted, often enlightened, and always encouraged to pursue Him more passionately. Our desire to know Him and grow in intimacy with Him increases as our understanding grows.

But we are to do more than simply read and study. We are to be "doers of the Word" as well. The apostle James reminds us of our responsibility: "Be doers of the word and not hearers only, deceiving yourselves. For if anyone is a hearer of the word and not a doer, he is like a man viewing his natural face in a mirror. He views himself, and goes his way, and immediately forgets what kind of man he was" (James 1:22–24, MEV).

One way to ensure that we are doers of the Word is to record what we learn when we study so that we can review it often and remember to put it into practice. The purpose of this book is to make it easy for you do just that—record, review, and apply. It was designed as a tool to help you get the most out of your devotional times. Each page provides a place for you to write down the book, chapter, and verse or verses you are studying; tell what you believe God is saying to you through the passage; describe what you learned; and compose a prayer asking God to help you apply what you learned to your life.

Now that you have the proper tool to maximize the benefit gained from your efforts, let's look at how you can best approach your study times.

■ First, find a quiet location that has a place for you to sit and a surface (such as a table or a desk)
with plenty of room for your open Bible, Bible-study journal, and perhaps a Bible commentary or dictionary.

■ Second, choose a Bible-reading plan that works for you. You may decide to read through the Bible in a year, choosing a passage from both the Old and the New Testaments each day. You may want to study a particular section, such as the Gospels, the Epistles, the Proverbs, or the Psalms. You may want to follow along with a Bible study being hosted by your church or a favorite minister you listen to. Or you may simply want to be led by the Holy Spirit when you sit down to spend time with Him. Whatever you decide, don't be afraid to change it up! Just try to be consistent in reading daily.

■ Third, begin with prayer, asking God to guide you in your reading, to help you understand the text, and to show you how it applies to your life.

■ Fourth, read the passage for the day—preferably out loud and if time allows, more than once—and then take time to reflect. Give God an opportunity to provide insight or speak a word into your spirit about it.

■ Finally, record what you learn in a page of this Bible-study journal—and enjoy coloring the design elements provided for that purpose.

*As you are faithful to your study, God will reward you with greater knowledge
of and intimacy with Him. That's something to look forward to!*

TODAY'S DATE

WHAT I'M READING

What GOD is SPEAKING to my heart

Prayer

WHAT I LEARNED

WHAT I'M READING

TODAY'S DATE

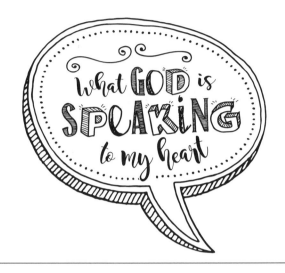

What GOD is SPEAKING to my heart

Prayer

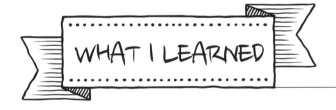

WHAT I LEARNED

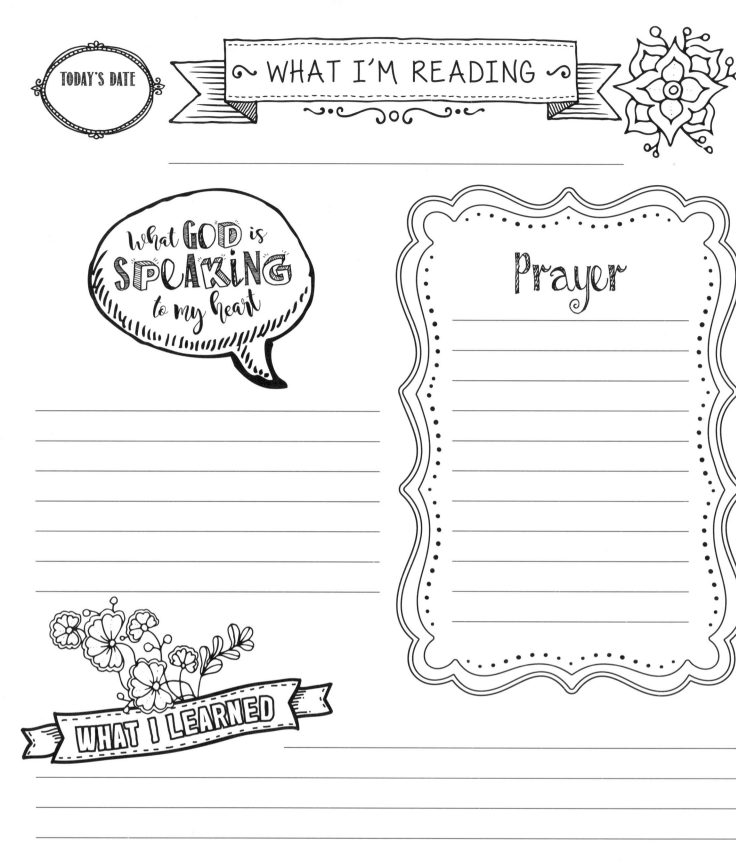

TODAY'S DATE

WHAT I'M READING

What GOD is SPEAKING to my heart

Prayer

WHAT I LEARNED

~ WHAT I'M READING ~

TODAY'S DATE

what GOD is SPEAKING to my heart

Prayer

WHAT I LEARNED

WHAT I'M READING

What GOD is SPEAKING to my heart

Prayer

WHAT I LEARNED

WHAT I'M READING

TODAY'S DATE

what GOD is SPEAKING to my heart

Prayer

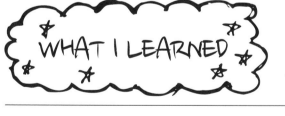

WHAT I LEARNED

TODAY'S DATE

WHAT I'M READING

What GOD is SPEAKING to my heart

Prayer

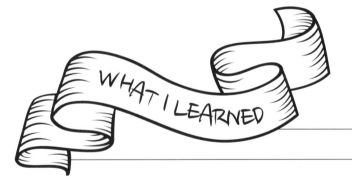
WHAT I LEARNED

WHAT I'M READING

TODAY'S DATE

What GOD is SPEAKING to my heart

Prayer

WHAT I LEARNED

TODAY'S DATE

WHAT I'M READING

what GOD is SPEAKING to my heart

Prayer

WHAT I LEARNED

WHAT I'M READING

TODAY'S DATE

what GOD is SPEAKING to my heart

Prayer

WHAT I LEARNED

WHAT I'M READING

what GOD is SPEAKING to my heart

Prayer

WHAT I LEARNED

WHAT I'M READING

TODAY'S DATE

what GOD is SPEAKING to my heart

Prayer

WHAT I LEARNED

WHAT I'M READING

TODAY'S DATE

What GOD is SPEAKING to my heart

WHAT I LEARNED

Prayer

TODAY'S DATE

WHAT I'M READING

what GOD is SPEAKING to my heart

Prayer

WHAT I LEARNED

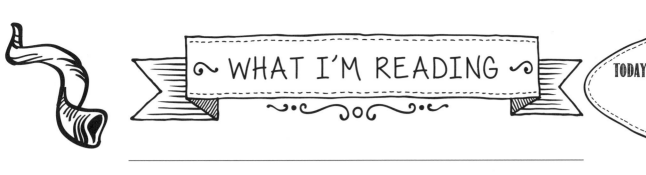

WHAT I'M READING

TODAY'S DATE

What GOD is SPEAKING to my heart

Prayer

WHAT I LEARNED

TODAY'S DATE

WHAT I'M READING

What GOD is SPEAKING to my heart

Prayer

WHAT I LEARNED

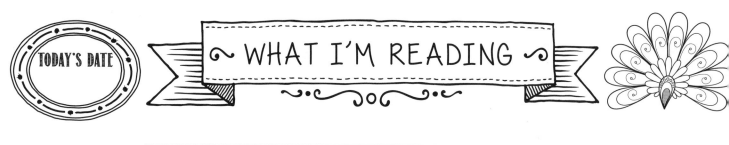

TODAY'S DATE

WHAT I'M READING

what GOD is SPEAKING to my heart

Prayer

WHAT I LEARNED

WHAT I'M READING

TODAY'S DATE

What GOD is SPEAKING to my heart

Prayer

WHAT I LEARNED

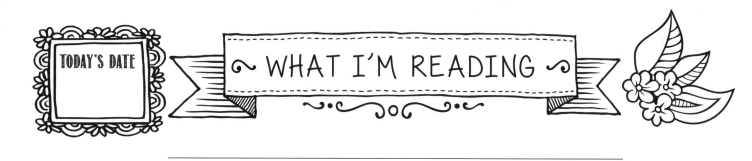

TODAY'S DATE

WHAT I'M READING

what GOD is SPEAKING to my heart

Prayer

WHAT I LEARNED

WHAT I'M READING

TODAY'S DATE

What GOD is SPEAKING to my heart

Prayer

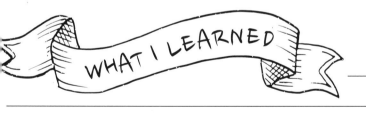

WHAT I LEARNED

TODAY'S DATE

WHAT I'M READING

what GOD is SPEAKING to my heart

Prayer

WHAT I LEARNED

WHAT I'M READING

TODAY'S DATE

what GOD is SPEAKING to my heart

Prayer

WHAT I LEARNED

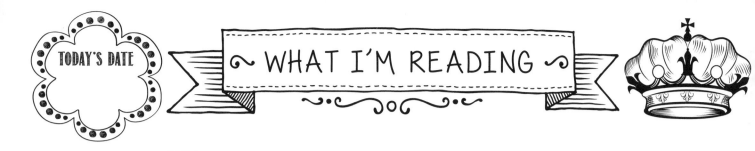

TODAY'S DATE

WHAT I'M READING

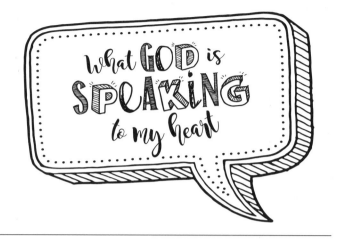

What GOD is SPEAKING to my heart

Prayer

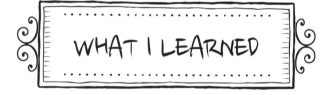

WHAT I LEARNED

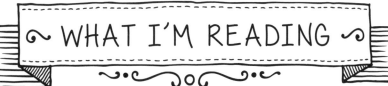
~ WHAT I'M READING ~

TODAY'S DATE

What GOD is SPEAKING to my heart

Prayer

WHAT I LEARNED

TODAY'S DATE

WHAT I'M READING

what GOD is SPEAKING to my heart

Prayer

WHAT I LEARNED

WHAT I'M READING

TODAY'S DATE

what GOD is SPEAKING to my heart

Prayer

WHAT I LEARNED

TODAY'S DATE

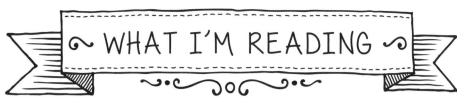

~ WHAT I'M READING ~

What GOD is SPEAKING to my heart

Prayer

WHAT I LEARNED

WHAT I'M READING

TODAY'S DATE

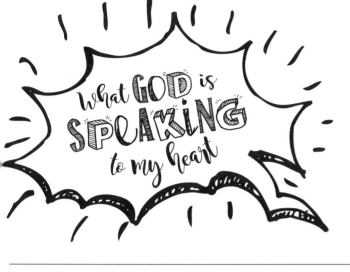
what GOD is SPEAKING to my heart

Prayer

WHAT I LEARNED

TODAY'S DATE

WHAT I'M READING

What GOD is SPEAKING to my heart

Prayer

WHAT I LEARNED

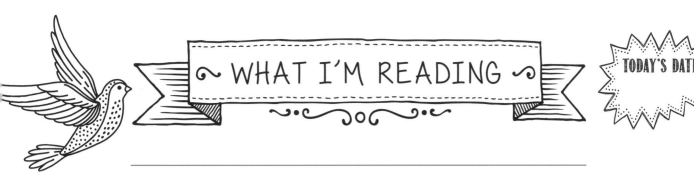

WHAT I'M READING

TODAY'S DATE

What GOD is SPEAKING to my heart

Prayer

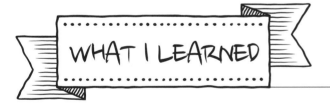

WHAT I LEARNED

TODAY'S DATE

WHAT I'M READING

What GOD is SPEAKING to my heart

Prayer

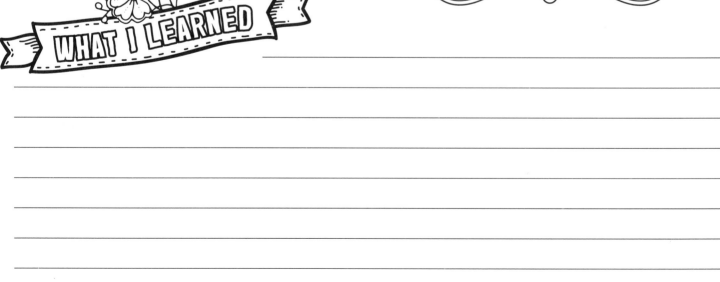

WHAT I LEARNED

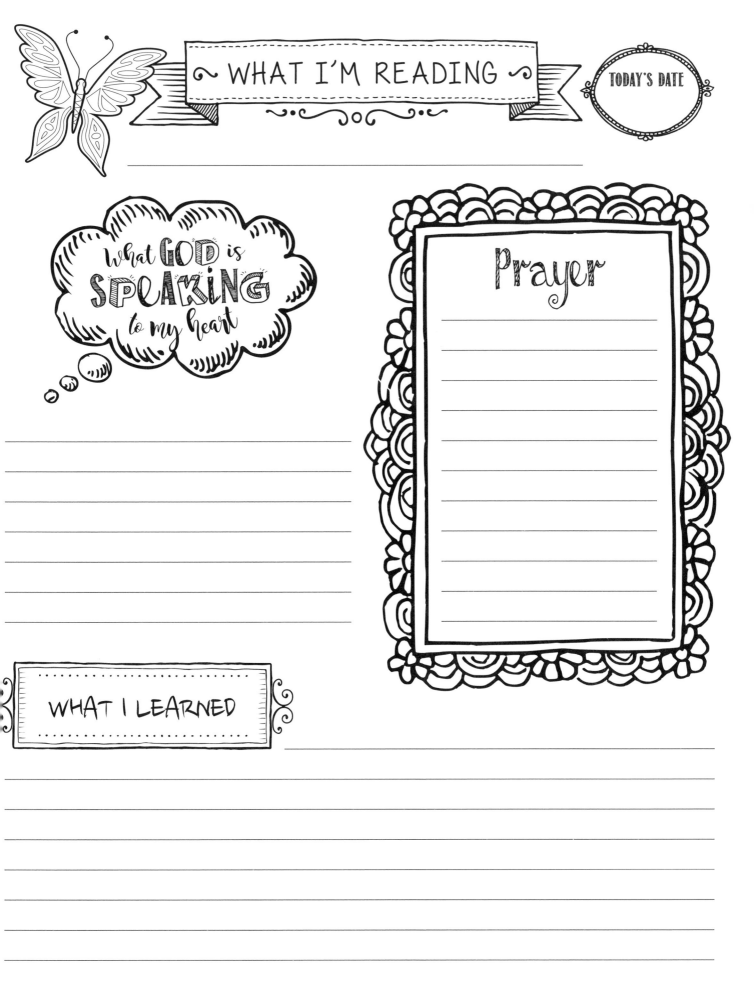

-∽ WHAT I'M READING ∽-

TODAY'S DATE

What GOD is SPEAKING to my heart

Prayer

WHAT I LEARNED

TODAY'S DATE

WHAT I'M READING

what GOD is SPEAKING to my heart

Prayer

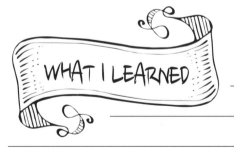

WHAT I LEARNED

WHAT I'M READING

TODAY'S DATE

what GOD is SPEAKING to my heart

Prayer

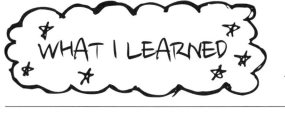
WHAT I LEARNED

TODAY'S DATE

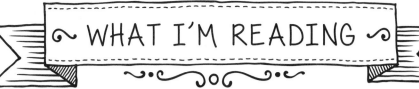
~ WHAT I'M READING ~

What GOD is SPEAKING to my heart

Prayer

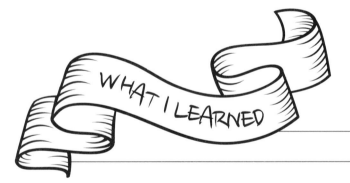
WHAT I LEARNED

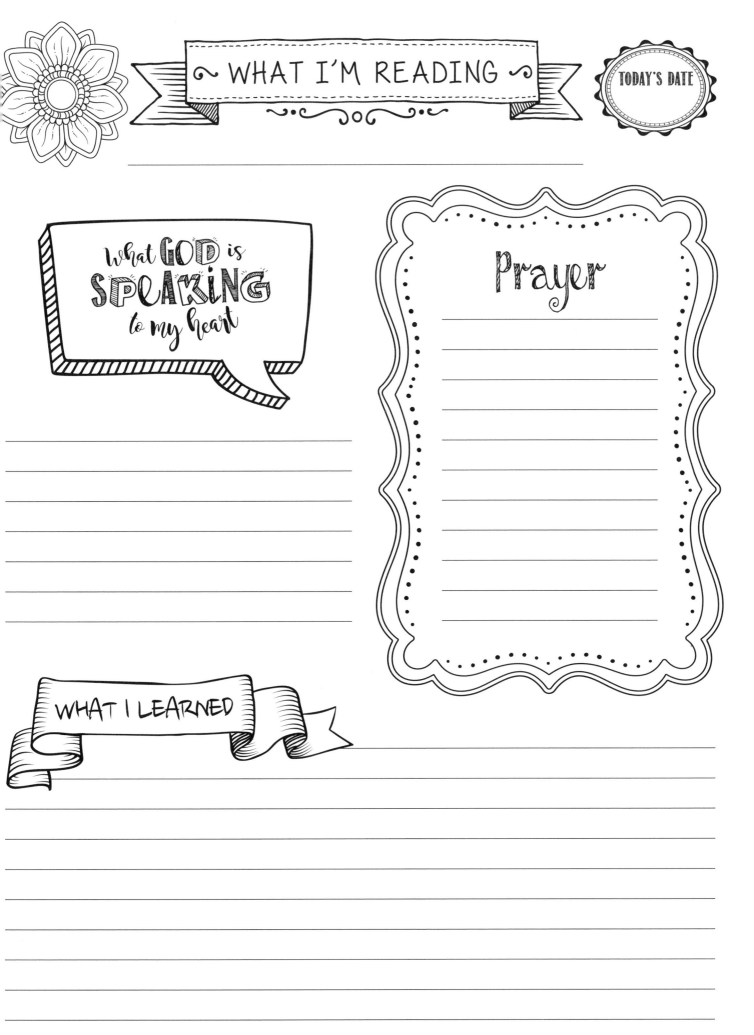

WHAT I'M READING

TODAY'S DATE

What GOD is SPEAKING to my heart

Prayer

WHAT I LEARNED

TODAY'S DATE

WHAT I'M READING

what GOD is SPEAKING to my heart

Prayer

WHAT I LEARNED

~ WHAT I'M READING ~

TODAY'S DATE

what GOD is SPEAKING to my heart

Prayer

WHAT I LEARNED

TODAY'S DATE

WHAT I'M READING

What GOD is SPEAKING to my heart

Prayer

WHAT I LEARNED

WHAT I'M READING

TODAY'S DATE

what GOD is SPEAKING to my heart

Prayer

WHAT I LEARNED

WHAT I'M READING

TODAY'S DATE

What GOD is SPEAKING to my heart

Prayer

WHAT I LEARNED

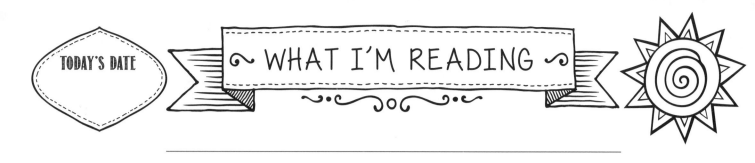

TODAY'S DATE

WHAT I'M READING

Prayer

WHAT I LEARNED

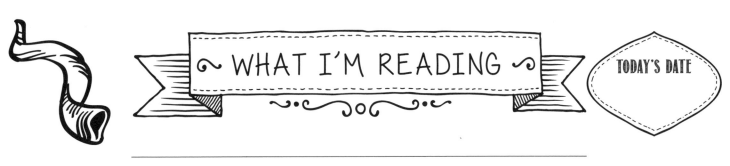

WHAT I'M READING

TODAY'S DATE

What GOD is SPEAKING to my heart

Prayer

WHAT I LEARNED

TODAY'S DATE

WHAT I'M READING

What GOD is SPEAKING to my heart

Prayer

WHAT I LEARNED

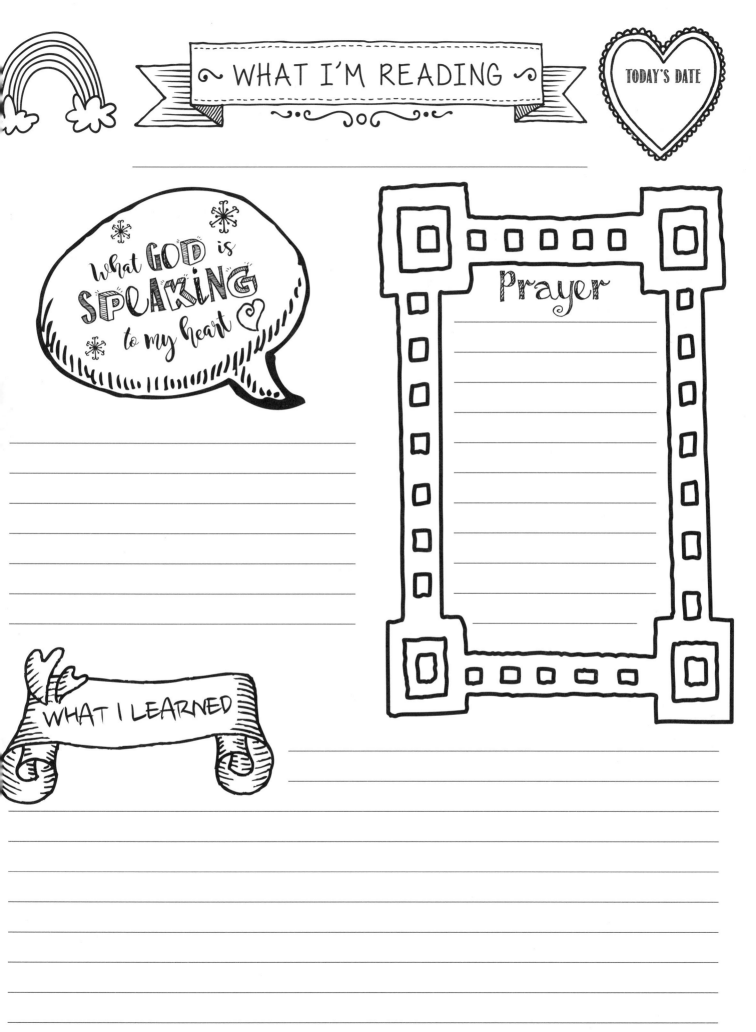

WHAT I'M READING

TODAY'S DATE

What GOD is SPEAKING to my heart

Prayer

WHAT I LEARNED

TODAY'S DATE

WHAT I'M READING

what GOD is SPEAKING to my heart

Prayer

WHAT I LEARNED

WHAT I'M READING

TODAY'S DATE

What GOD is SPEAKING to my heart

Prayer

WHAT I LEARNED

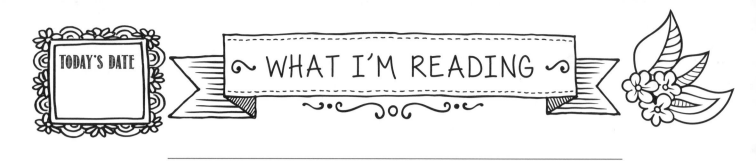

TODAY'S DATE

WHAT I'M READING

Prayer

WHAT I LEARNED

WHAT I'M READING

TODAY'S DATE

What GOD is SPEAKING to my heart

Prayer

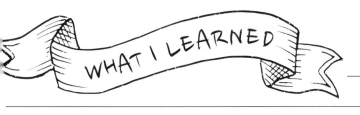

WHAT I LEARNED

TODAY'S DATE

WHAT I'M READING

What GOD is SPEAKING to my heart

Prayer

WHAT I LEARNED

WHAT I'M READING

What GOD is SPEAKING to my heart

Prayer

WHAT I LEARNED

TODAY'S DATE

WHAT I'M READING

What GOD is SPEAKING to my heart

Prayer

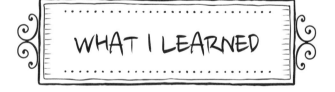

WHAT I LEARNED

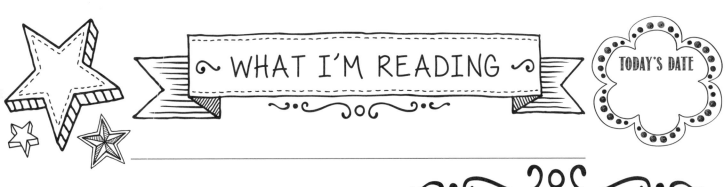

WHAT I'M READING

TODAY'S DATE

what GOD is SPEAKING to my heart

Prayer

WHAT I LEARNED

TODAY'S DATE

WHAT I'M READING

what GOD is SPEAKING to my heart

Prayer

WHAT I LEARNED

WHAT I'M READING

TODAY'S DATE

What GOD is SPEAKING to my heart

Prayer

WHAT I LEARNED

TODAY'S DATE

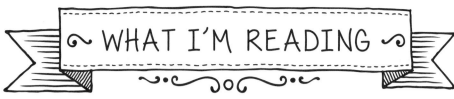

~ WHAT I'M READING ~

What GOD is SPEAKING to my heart

Prayer

WHAT I LEARNED

WHAT I'M READING

TODAY'S DATE

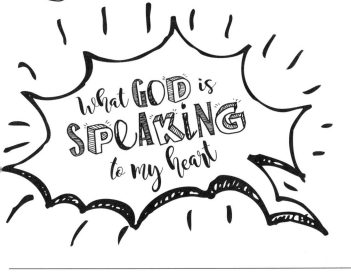
What GOD is SPEAKING to my heart

Prayer

WHAT I LEARNED

~ WHAT I'M READING ~

What GOD is SPEAKING to my heart

Prayer

WHAT I LEARNED

WHAT I'M READING

TODAY'S DATE

What GOD is SPEAKING to my heart

Prayer

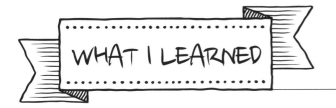

WHAT I LEARNED

TODAY'S DATE

WHAT I'M READING

What GOD is SPEAKING to my heart

Prayer

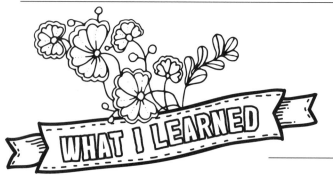

WHAT I LEARNED

WHAT I'M READING

TODAY'S DATE

what GOD is SPEAKING to my heart

Prayer

WHAT I LEARNED

TODAY'S DATE

WHAT I'M READING

What GOD is SPEAKING to my heart

Prayer

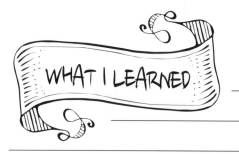

WHAT I LEARNED _____

WHAT I'M READING

TODAY'S DATE

what GOD is SPEAKING to my heart

Prayer

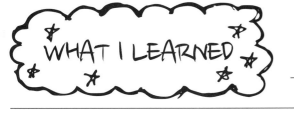
WHAT I LEARNED

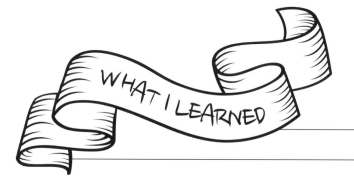

WHAT I'M READING

TODAY'S DATE

what GOD is SPEAKING to my heart

Prayer

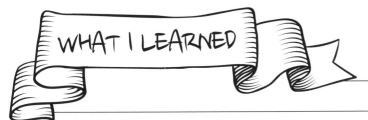

WHAT I LEARNED

TODAY'S DATE

WHAT I'M READING

what GOD is SPEAKING to my heart

Prayer

WHAT I LEARNED

WHAT I'M READING

TODAY'S DATE

What GOD is SPEAKING to my heart

Prayer

WHAT I LEARNED

TODAY'S DATE

WHAT I'M READING

what GOD is SPEAKING to my heart

Prayer

WHAT I LEARNED

WHAT I'M READING

TODAY'S DATE

what GOD is SPEAKING to my heart

Prayer

WHAT I LEARNED

TODAY'S DATE

WHAT I'M READING

what GOD is SPEAKING to my heart

Prayer

WHAT I LEARNED

TODAY'S DATE

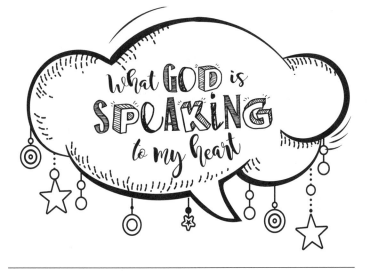

What GOD is SPEAKING to my heart

Prayer

WHAT I LEARNED

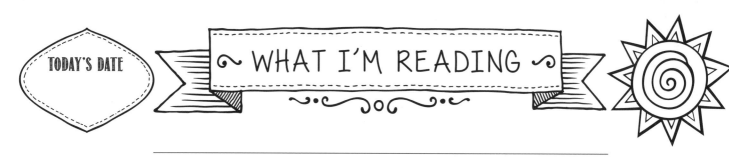

TODAY'S DATE

~ WHAT I'M READING ~

what GOD is SPEAKING to my heart

Prayer

WHAT I LEARNED

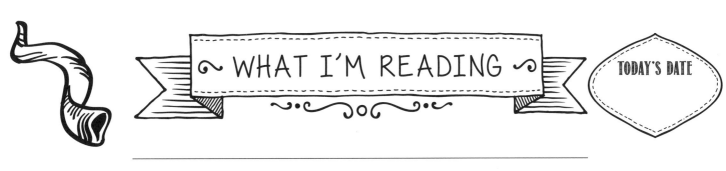

WHAT I'M READING

TODAY'S DATE

what GOD is SPEAKING to my heart

Prayer

WHAT I LEARNED

TODAY'S DATE

WHAT I'M READING

What GOD is SPEAKING to my heart

Prayer

WHAT I LEARNED

WHAT I'M READING

TODAY'S DATE

What GOD is SPEAKING to my heart

Prayer

WHAT I LEARNED

TODAY'S DATE

WHAT I'M READING

What GOD is SPEAKING to my heart

Prayer

WHAT I LEARNED

~ WHAT I'M READING ~

TODAY'S DATE

What GOD is SPEAKING to my heart

Prayer

WHAT I LEARNED

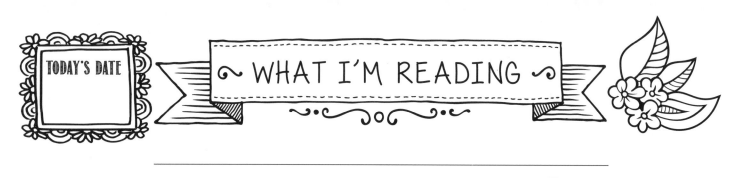

TODAY'S DATE

WHAT I'M READING

What GOD is SPEAKING to my heart

Prayer

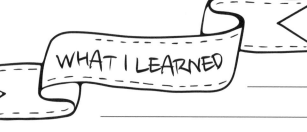

WHAT I LEARNED

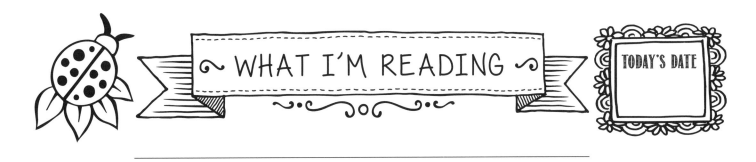

WHAT I'M READING

TODAY'S DATE

what GOD is SPEAKING to my heart

Prayer

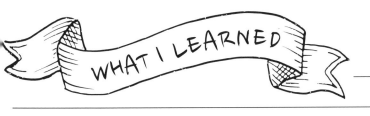

WHAT I LEARNED

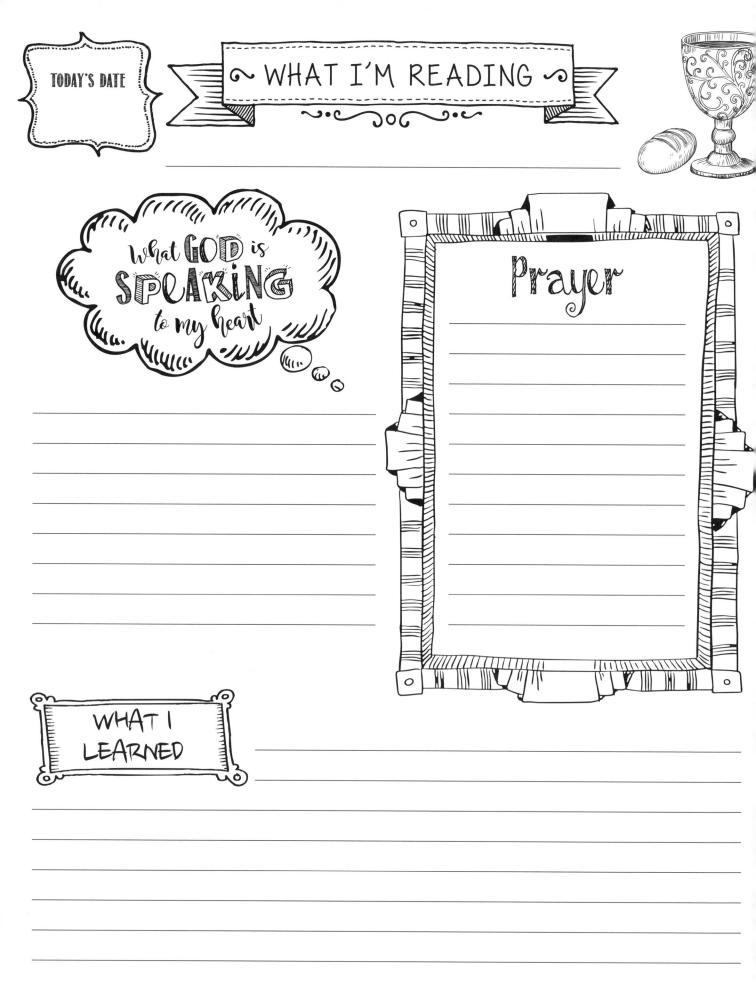

TODAY'S DATE

~ WHAT I'M READING ~

What GOD is SPEAKING to my heart

Prayer

WHAT I LEARNED

WHAT I'M READING

TODAY'S DATE

What GOD is SPEAKING to my heart

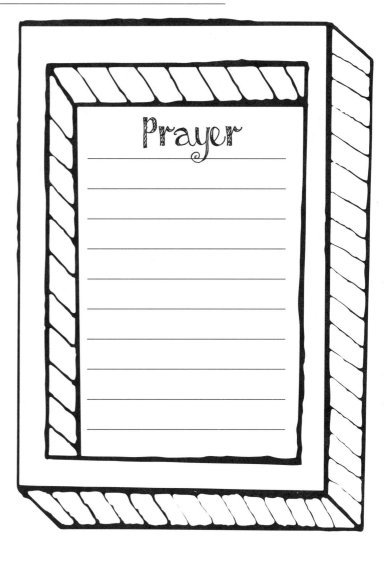
Prayer

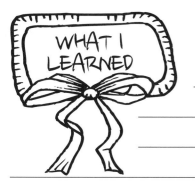
WHAT I LEARNED

WHAT I'M READING

what GOD is SPEAKING to my heart

Prayer

WHAT I LEARNED

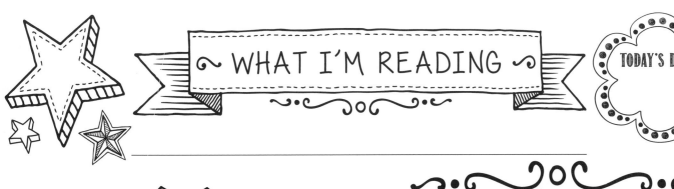

WHAT I'M READING

TODAY'S DATE

what GOD is SPEAKING to my heart

Prayer

WHAT I LEARNED

TODAY'S DATE

WHAT I'M READING

What GOD is SPEAKING to my heart

Prayer

WHAT I LEARNED

~ WHAT I'M READING ~

TODAY'S DATE

what GOD is SPEAKING to my heart

Prayer

WHAT I LEARNED

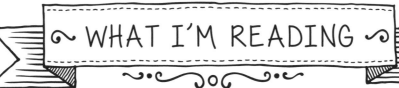

~ WHAT I'M READING ~

What GOD is SPEAKING to my heart

Prayer

WHAT I LEARNED

TODAY'S DATE

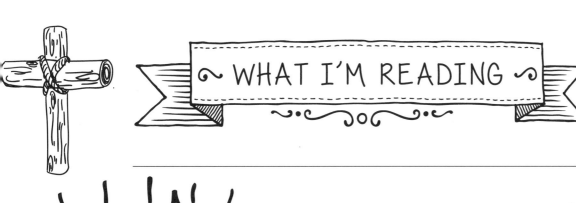

WHAT I'M READING

What GOD is SPEAKING to my heart

Prayer

WHAT I LEARNED

Walk in love, as Christ loved us and gave Himself for us as a fragrant offering and a sacrifice to God.

Ephesians 5:2

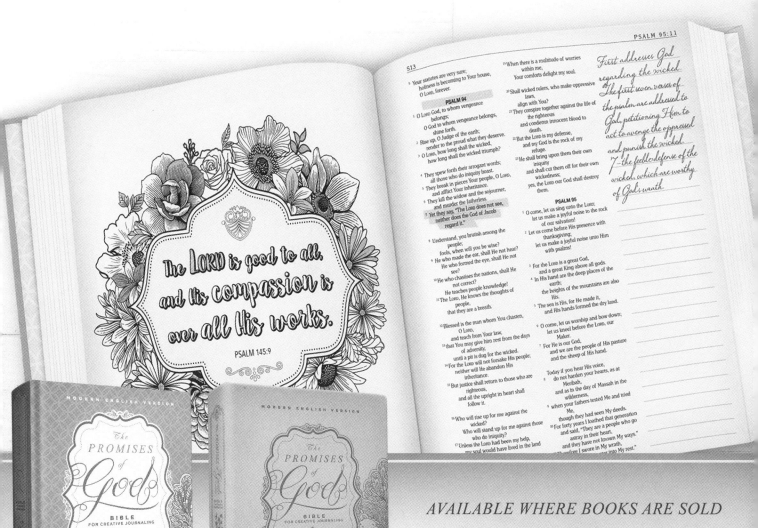

Most CHARISMA HOUSE BOOK GROUP products are available at special quantity
discounts for bulk purchase for sales promotions, premiums, fund-raising,
and educational needs. For details, write Charisma House Book Group,
600 Rinehart Road, Lake Mary, Florida 32746, or telephone (407) 333-0600.

BE STILL, MY SOUL 90-DAY BIBLE STUDY COLORING JOURNAL published by Passio
Charisma Media/Charisma House Book Group
600 Rinehart Road
Lake Mary, Florida 32746
www.charismahouse.com

All Scripture quotations are taken from the Holy Bible, Modern English Version.
Copyright © 2014 by Military Bible Association.
Used by permission. All rights reserved.

Design Director: Justin Evans
Cover Design: Justin Evans
Interior Design: Justin Evans, Lisa Rae McClure, Vincent Pirozzi

Illustrations: Getty Images/Depositphotos

International Standard Book Number: 978-1-62999-077-4

17 18 19 20 21 — 987654321

Printed in the United States of America